Praise for *Insi*

"A beautiful expression of everyday life seldom seen by those not immersed in Old Order Amish communities. Opening the pages of *Inside an Amish Home* leaves readers feeling as though they've stepped over the threshold and into the lives of our Amish friends. A true cultural treasure!"

—SHERRY GORE, author of *The Plain Choice*

"Peppered with exquisite photos, this respectful backstage tour offers an authentic glimpse of daily life. *Inside an Amish Home* offers a succinct yet gracious window into the world of the Amish, showcasing the seasonal rhythms of family life and the wells of Amish spirituality."

—DONALD B. KRAYBILL, author of *The Riddle of Amish Culture*

"From bread-making to buggy travel, *Inside an Amish Home* provides a unique glimpse into Plain life. Beautiful photography captures daily family tasks and chores, celebrating ordinary moments of time-honored traditions."

—SUZANNE WOODS FISHER, bestselling author of *Amish Peace*

"With beautiful photos and respectful text, this book introduces you to the heart of Amish life. The home remains central to Amish experience—a place not only of daily chores and mealtime conversation but also of childbirth, church services, weddings, and funerals."

—STEVEN M. NOLT, author of *The Amish: A Concise Introduction*

Inside an

AMISH
HOME

A Rare and Intimate Portrait

HERALD
PRESS

Harrisonburg, Virginia

Herald Press
PO Box 866, Harrisonburg, Virginia 22803
www.HeraldPress.com

The Library of Congress has cataloged the hardcover edition as follows:
Library of Congress Cataloging-in-Publication Data
Names: Herald Press (Harrisonburg, Va.), issuing body.
Title: Inside an Amish home : a rare and intimate portrait.
Description: Harrisonburg, Virginia : Herald Press, [2019]
Identifiers: LCCN 2018026627 | ISBN 9781513804255 (hardcover : alk. paper)
Subjects: LCSH: Amish--United States--Social life and customs. |
 Dwellings--United States. | Farm life--United States.
Classification: LCC E184.M45 I57 2019 | DDC 289.70973--dc23 LC record
available at https://lccn.loc.gov/2018026627

INSIDE AN AMISH HOME
© 2019 by Herald Press, Harrisonburg, Virginia 22803. 800-245-7894.
 All rights reserved.
Library of Congress Control Number: 2018026627
International Standard Book Number: 978-1-5138-0424-8 (paperback);
 978-1-5138-0425-5 (hardcover)
Printed in China
Cover and interior design by Reuben Graham
Cover photo by Grant Beachy

Photo credits: Grant Beachy, Lucas Swartzentruber-Landis.

Unless otherwise noted, Scripture text is quoted, with permission, from the New
Revised Standard Version, © 1989, Division of Christian Education of the National
Council of Churches of Christ in the United States of America.

23 22 21 20 19 10 9 8 7 6 5 4 3 2 1

Welcome to an Amish home! It's rare for outsiders to see inside the homes of Old Order Amish people, who live their Christian faith in community, simplicity, and humility. The Old Order Amish reject many technologies, including cameras, believing that photographs of people's faces cultivate pride and individualism.

This Amish family, who lives in the Midwest, gives us a glimpse into the intimate spaces where their family life unfolds. Patterns of work, play, fellowship, and worship become visible, and the warmth and light of the rooms bear witness to their love for God and for each other. Welcome!

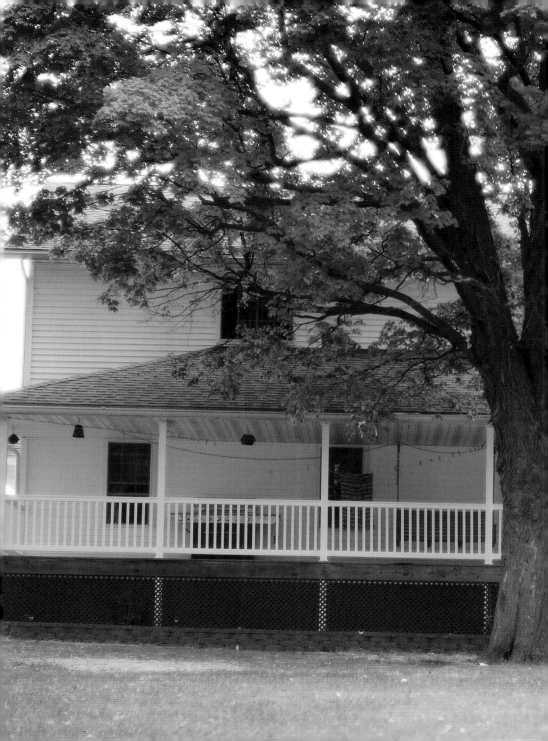

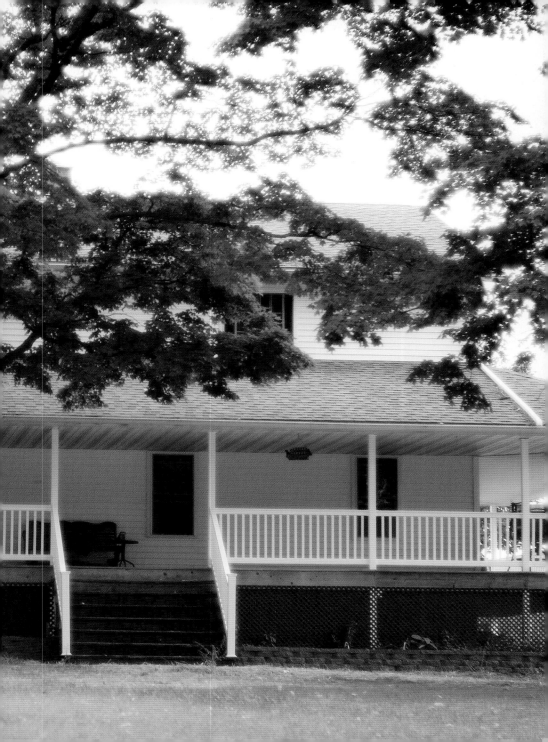

———

THE HOME SITS at the end of a lane that runs off a country road. Many but not all of the family's closest neighbors are Amish. The Amish have a strong preference for rural living, and many continue to make their primary living through farming. Increasingly, however, Amish families make their living in many other ways—through small manufacturing, construction, factory work, and merchandising.

"The earth is the Lord's and all that is in it, the world, and those who live in it."
—PSALM 24:1

AS YOU DRIVE in the lane, you'll see the family's laundry hanging on the line. Given the size of many Amish families, lengthy clotheslines, packed with clothes and linens, are a common sight in most Amish communities. Electric-powered dryers may be more convenient, but the Old Order Amish don't connect their homes to the electric grid. No worries—the sun provides all the drying power needed, and the fresh air will make the bedsheets even more inviting at bedtime.

"Every generous act of giving, with every perfect gift, is from above, coming down from the Father of lights, with whom there is no variation or shadow due to change."
—JAMES 1:17

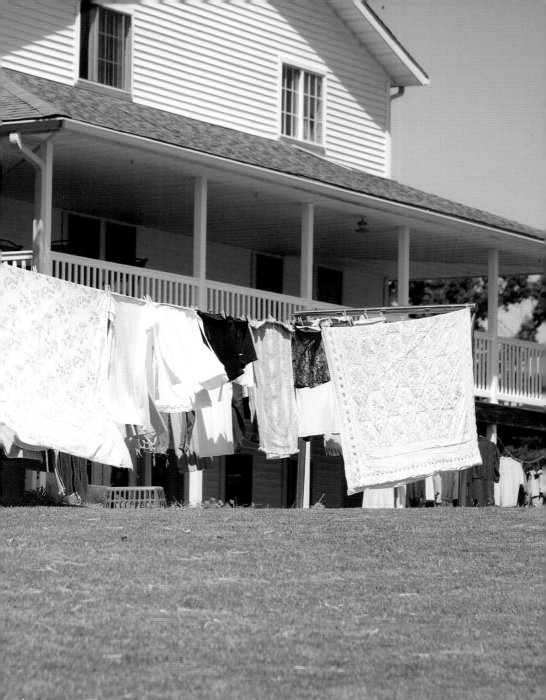

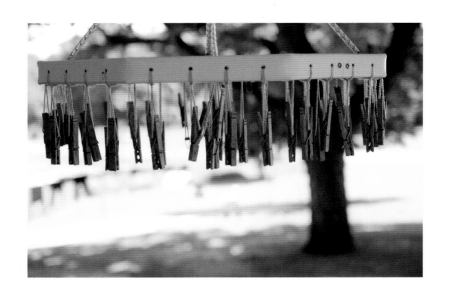

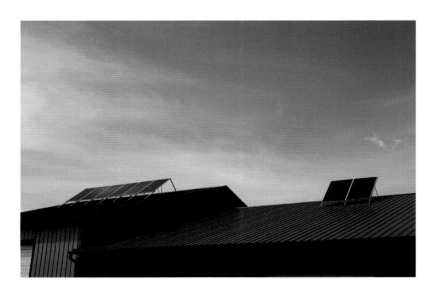

DON'T THINK that the Amish reject all technology. Not far from a rack of clothespins you'll see a modern technology that also takes advantage of the sun: solar panels on the roof of the family's workshop. Each Amish church district has its own *Ordnung*, a set of community-specific rules and regulations that church members are expected to follow. In this community, solar panels are permitted for powering saws, lathes, and other tools.

> *"Lead a life worthy of the calling to which you have been called, with all humility and gentleness, with patience, bearing with one another in love."*
> —EPHESIANS 4:1-2

AS YOU APPROACH the house, you may be greeted by a barn cat or kitten, or maybe the family's horse, who is harnessed to the buggy and ready for a trip to town. The Old Order Amish don't own cars because they see them as threats to their communities, which are built on face-to-face visits. By hiring drivers when they need to travel greater distances, the Amish have tried to accommodate to contemporary life but not be swallowed up by it.

"O Lord, how manifold are your works! In wisdom you have made them all; the earth is full of your creatures."
—PSALM 104:24

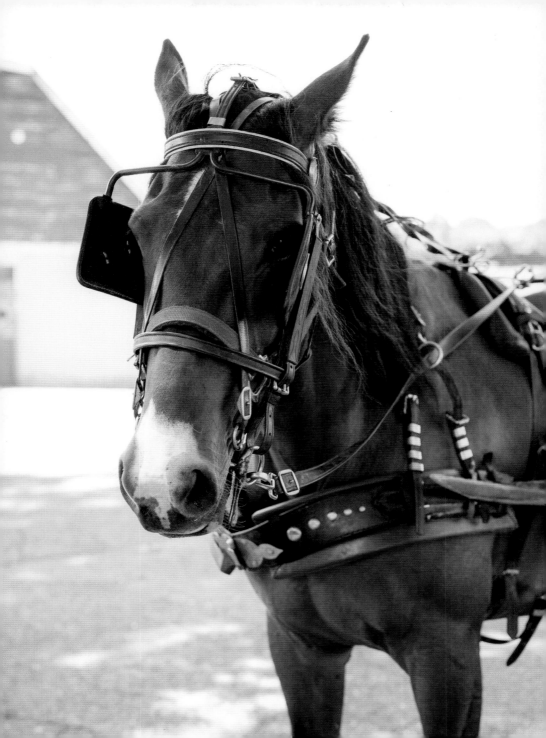

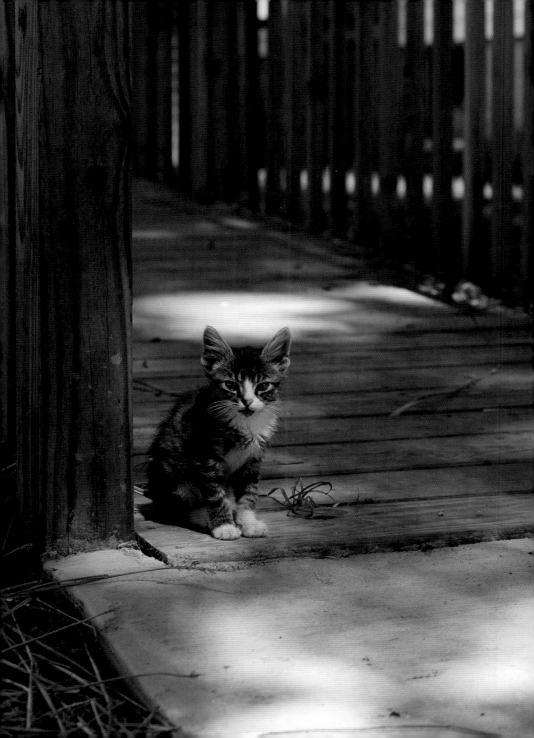

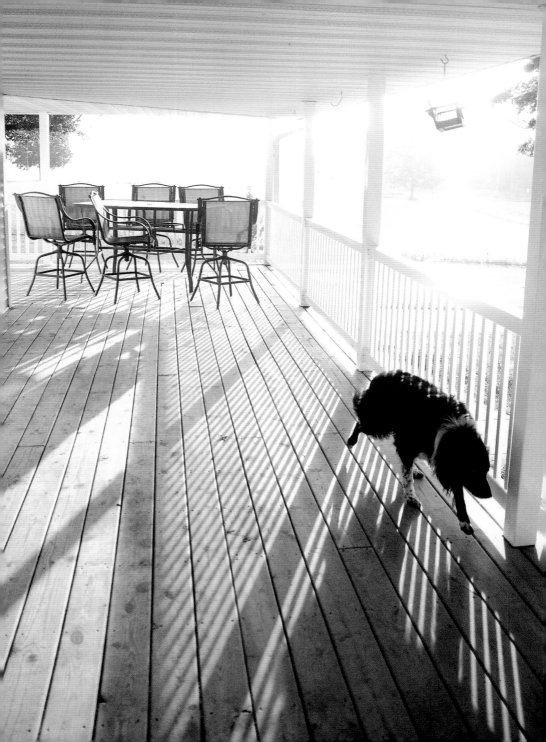

———————

THE FRONT PORCH of many Amish homes is the favorite place to visit when friends and family drop by. A porch swing invites guests to sit and stay awhile, and the family sometimes enjoys dinner at the table outside.

> *"Even the sparrow finds a home, and the swallow a nest*
> *for herself, where she may lay her young, at your altars, O*
> *Lord of hosts, my King and my God."*
> —PSALM 84:3

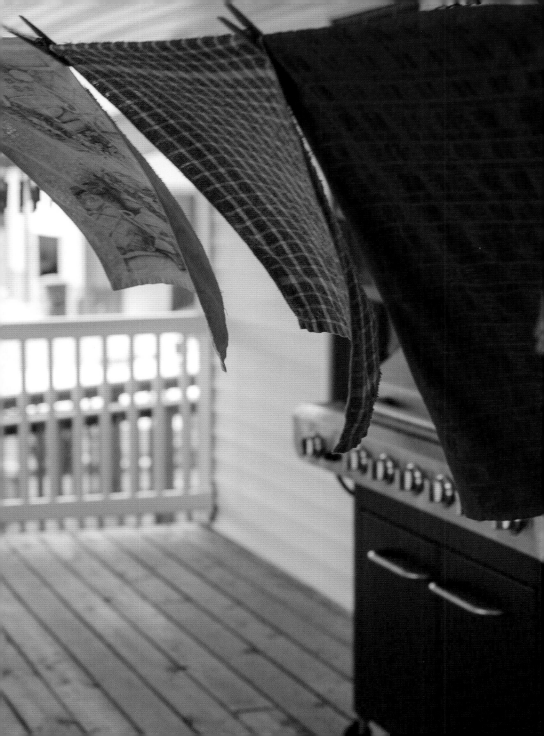

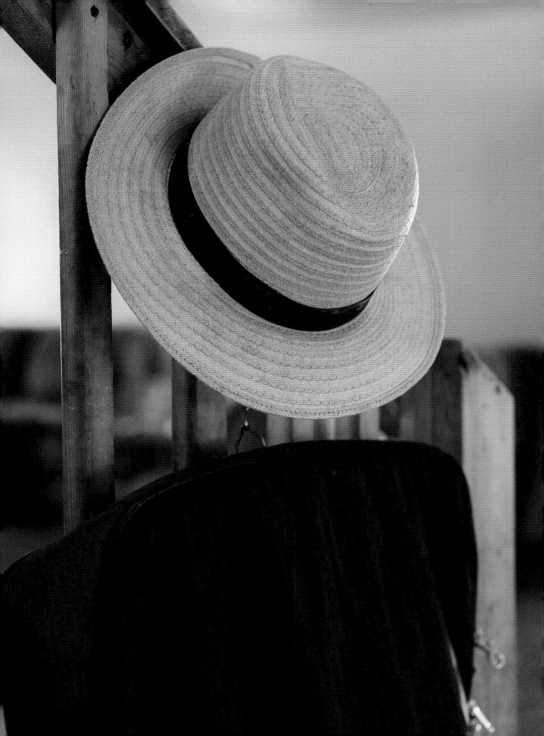

AS YOU COME through the front door, you'll enter a room bathed with light from the early afternoon sun. Without the benefit of electric lighting, many Amish homes have large windows that allow nature to light up the rooms and brighten the family's day.

"From the rising of the sun to its setting the name of the Lord is to be praised."
—PSALM 113:3

YOU MAY FIND the living room spare, but it is not without decorative features. Along with wall hangings and framed Bible verses, a grandfather clock sits in the corner, chiming out the hours of the day and night. The soft recliners are just the right thing for reading and dozing off, and they can quickly be pushed together when company stops by.

"Those who love me will keep my word, and my Father will love them, and we will come to them and make our home with them."
—JOHN 14:23

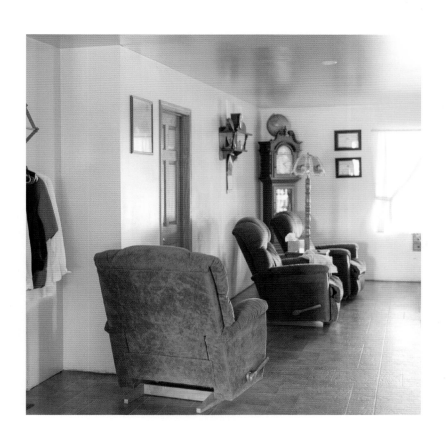

———————

ON CLOUDY DAYS, or when evening falls, gas-powered lights can quickly be put to use—for reading, writing letters, and a host of other activities. As a visitor, you'll surely notice how brightly the wick burns. You'll also catch a whiff of the propane gas, even when the lights aren't being used. In fact, many Amish homes include other gas-powered technologies, such as propane-powered refrigerators and stoves.

> *"No one after lighting a lamp hides it under a jar, or puts it under a bed, but puts it on a lampstand, so that those who enter may see the light."*
> —LUKE 8:16

HOLY BIBLE

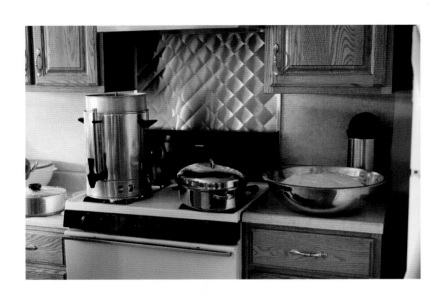

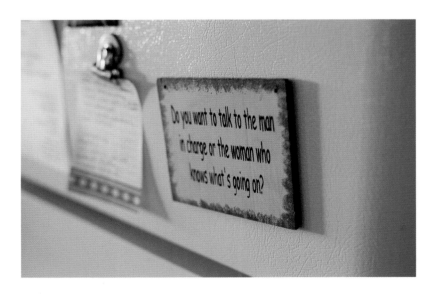

Do you want to talk to the man in charge or the woman who knows what's going on?

AMISH KITCHEN APPLIANCES may not run on electricity, but you might be surprised at how much the stove and refrigerator look like your own. As with the refrigerators in many non-Amish homes, you'll discover that this refrigerator doubles as the family's communication hub. Dotted with magnets and handwritten notes, it also displays a good-natured adage that may make you wonder who posted it in the first place.

"A cheerful heart is a good medicine, but a downcast spirit dries up the bones."
—PROVERBS 17:22

WITH DINNER not too far away, it's time to make bread. No recipe is needed for the experienced baker to find the right combination of flour, water, and yeast, and her hands know when the kneading is done. Buying bread at the store can help during a busy week, but the homemade loaves taste better and are much less expensive. The thick slices are good by themselves, but some family members like them even better when they're slathered with apple butter or homemade jam.

"You cause the grass to grow for the cattle, and plants for people to use, to bring forth food from the earth, and wine to gladden the human heart, oil to make the face shine, and bread to strengthen the human heart."
—PSALM 104:14-15

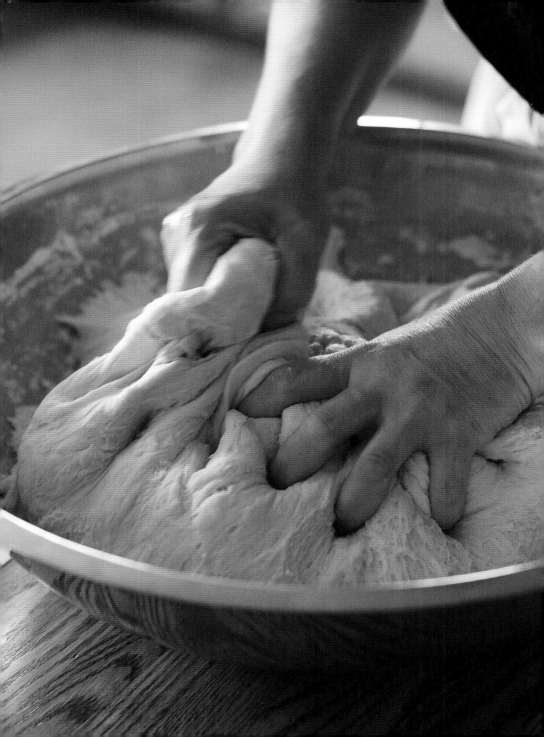

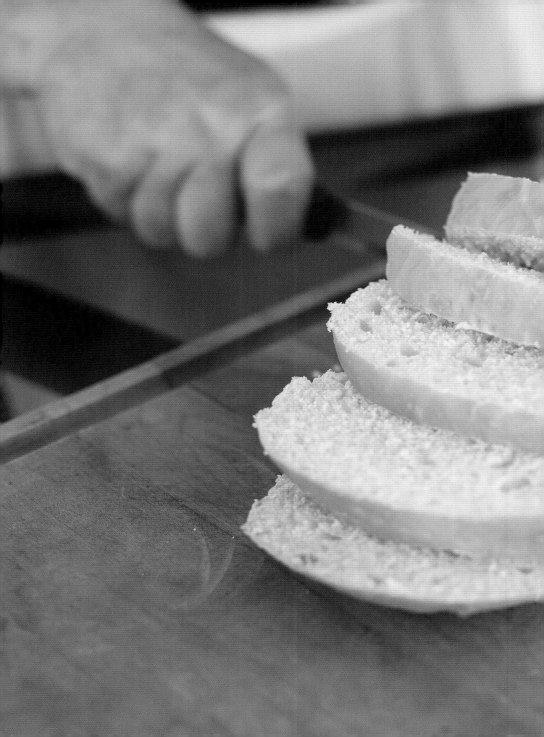

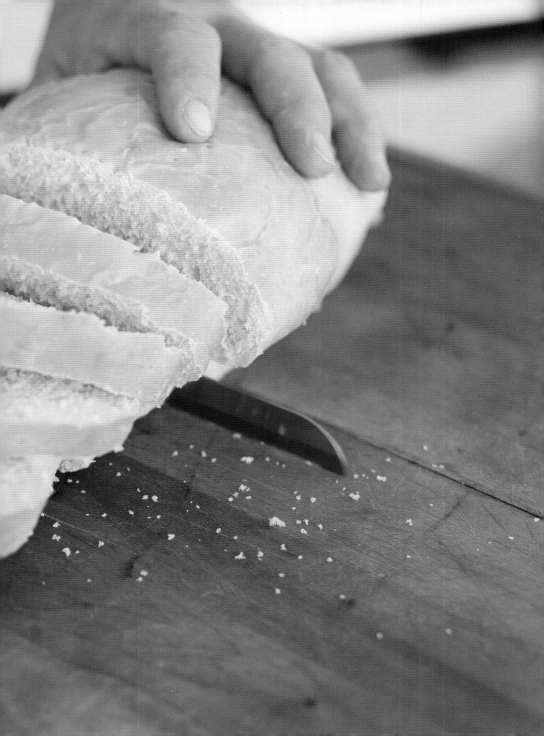

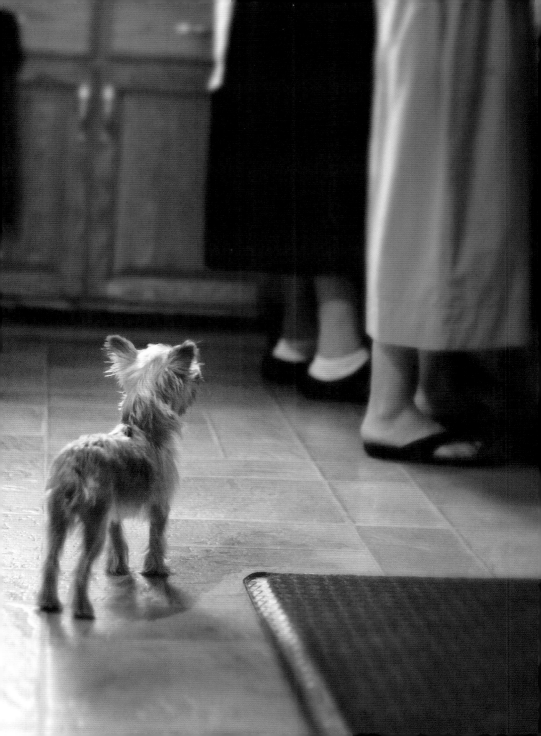

PREPARING MEALS is always better when it is accompanied by conversation. Food preparation in an Amish home is typically women's work, and daughters learn from a very early age what they can do to help. Of course, the family dog likes to be where the action is, especially when a scrap of food might make its way to the floor. The sound of familiar voices and the warmth of the oven make the kitchen chair the best spot for an afternoon snooze.

"He gives to the animals their food, and to the young ravens when they cry."
—PSALM 147:9

39

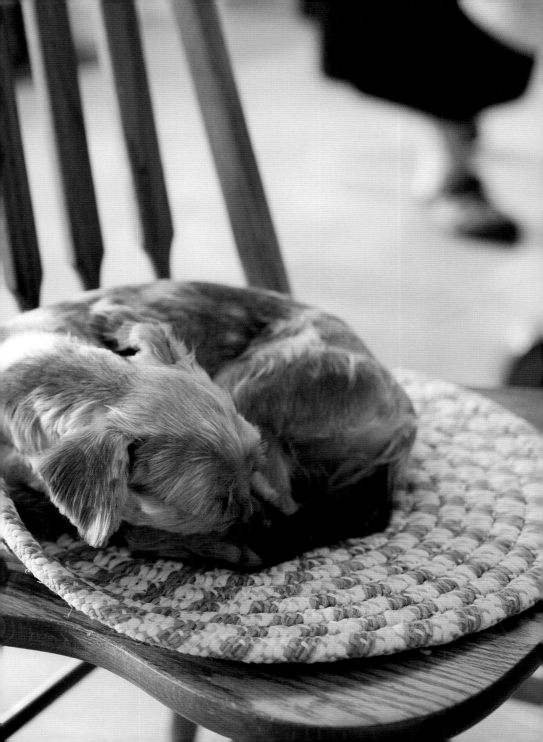

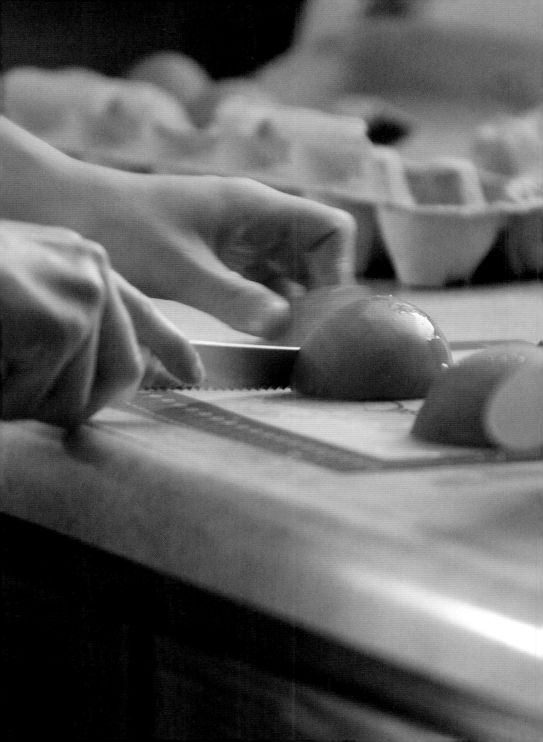

MOST AMISH FAMILIES, even those that don't farm for a living, have large gardens that provide produce in the summer and fall. Grape arbors and fruit trees provide even more home-grown food for dinner tables that serve eight, ten, or even twelve family members.

"He has not left himself without a witness in doing good—giving you rains from heaven and fruitful seasons, and filling you with food and your hearts with joy."
—ACTS 14:17

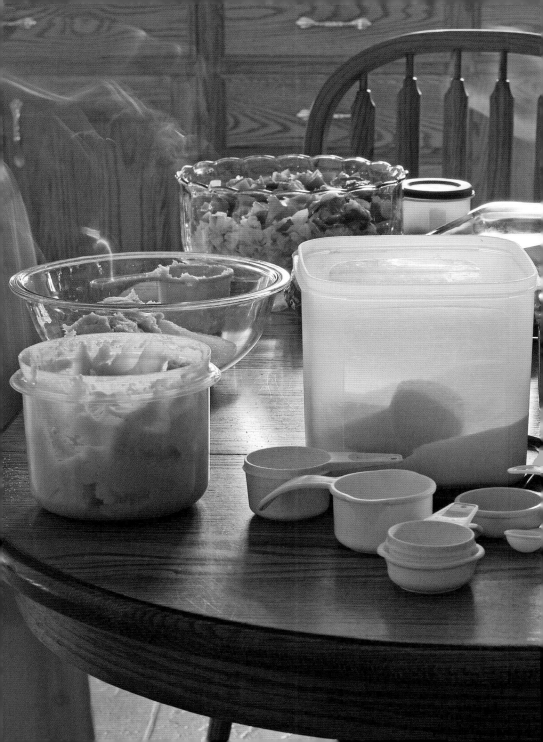

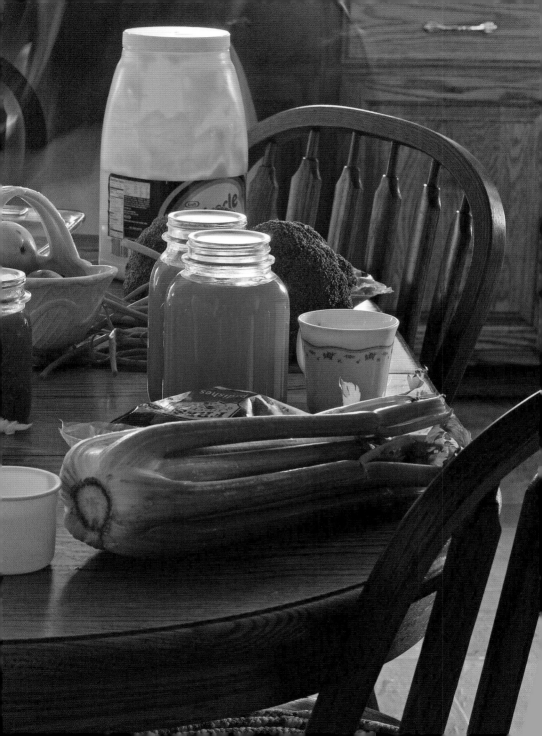

CANNING IS A LABOR-INTENSIVE activity that provides food for the family all year long. Tomatoes, corn, peaches, and pears are boiled and canned in their own juices. Cucumbers, beets, and other vegetables are pickled in a vinegar brine that adds a tangy flavor. Some Amish families enjoy a Pennsylvania Dutch relish called chow chow, a pickled concoction of green beans, carrots, celery, cauliflower, and kidney beans. This family also butchers and preserves meats.

"Consider the ravens: they neither sow nor reap, they have neither storehouse nor barn, and yet God feeds them. Of how much more value are you than the birds!"
—LUKE 12:24

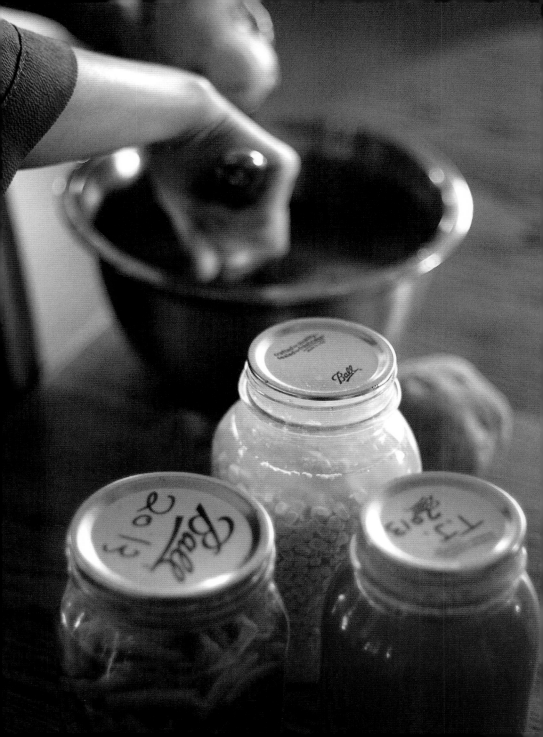

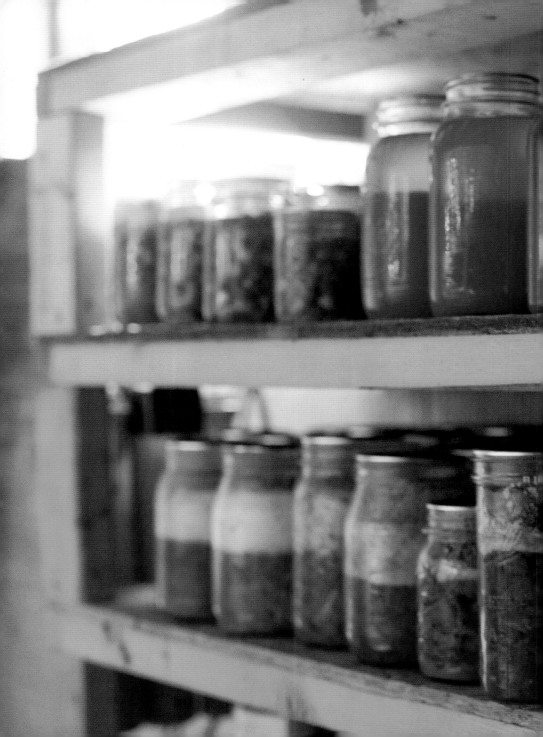

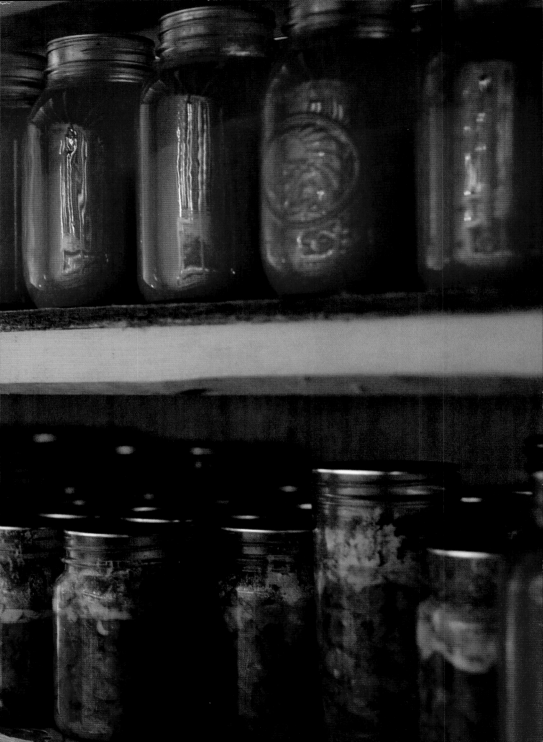

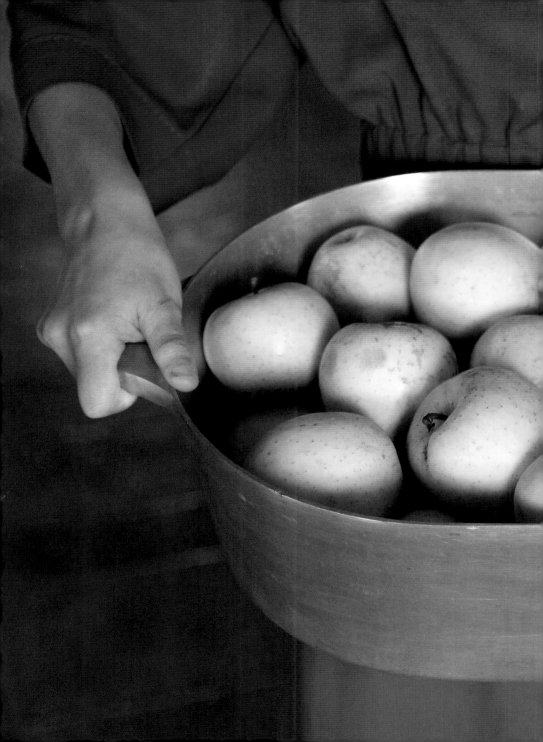

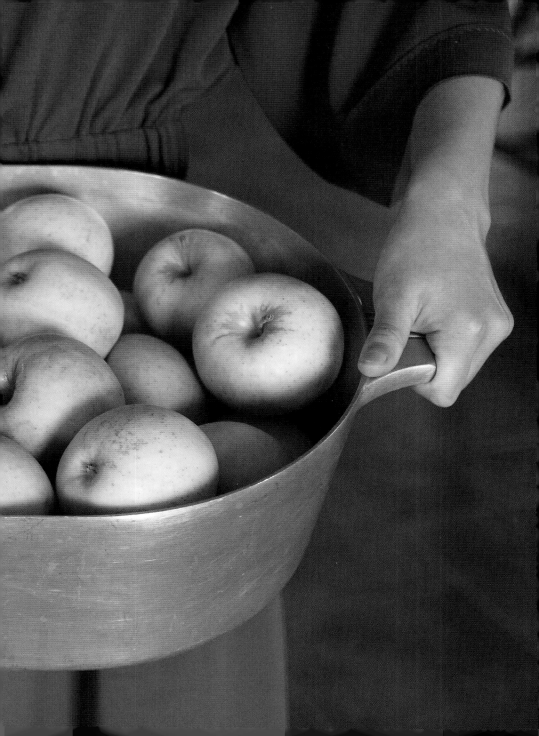

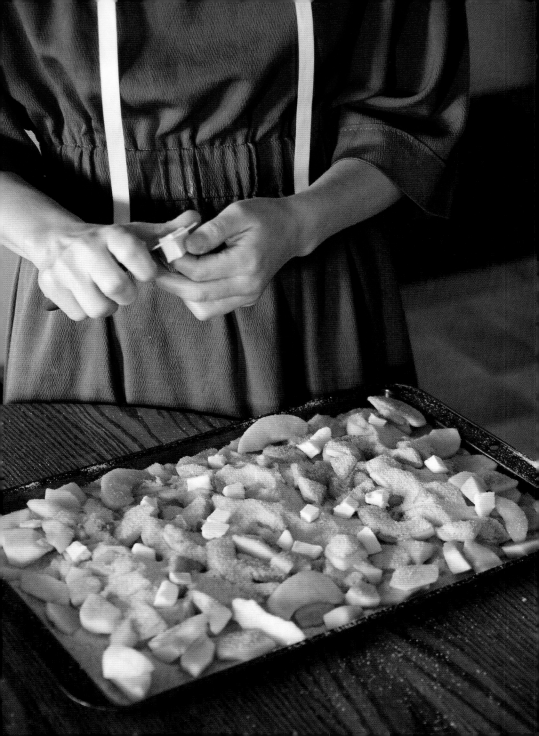

APPLES, purchased at a local market or perhaps from a neighbor's orchard, are good for making apple butter and sauce. Today they will be used for fresh-baked apple pie. Once the apples are peeled and sliced, they receive a generous coating of cinnamon and sugar. Before long they'll be ready to fill a pie shell or two—maybe even three!

> *"A word fitly spoken is like apples of gold in a setting of silver."*
> —PROVERBS 25:11

MAKING A GOOD PIE CRUST may look simple, but it is no easy thing—unless you've done it dozens of times. Many Amish cooks will tell you that the secret to a good crust is lard. That may be true, but it's also true that "practice makes perfect," so don't expect your lard-based crust to turn out well the first time you try it.

"Let the favor of the Lord our God be upon us, and prosper for us the work of our hands—O prosper the work of our hands!"
—PSALM 90:17

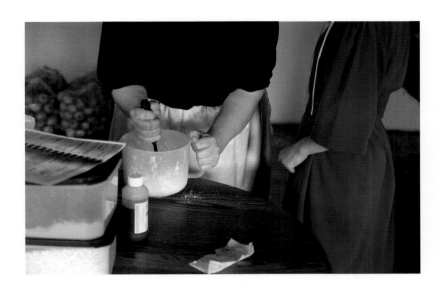

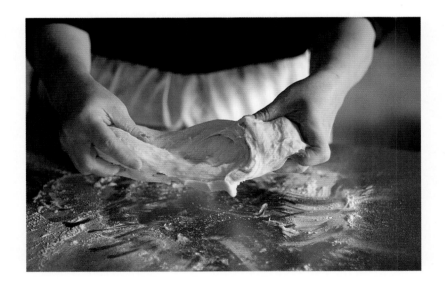

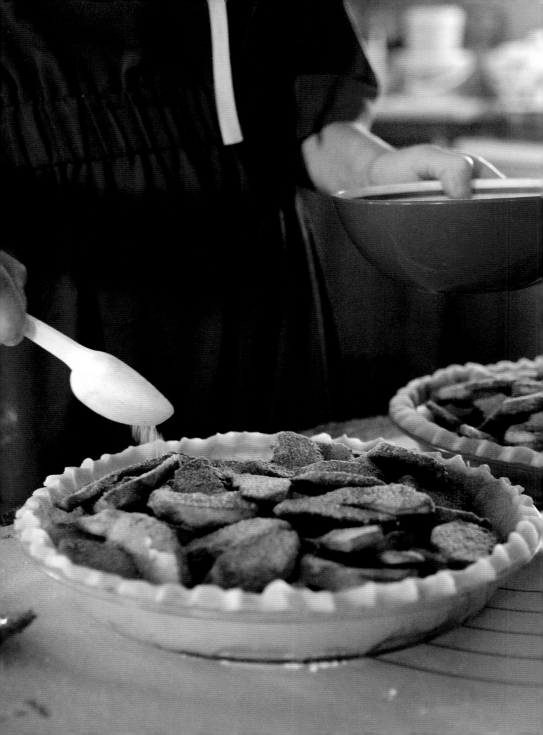

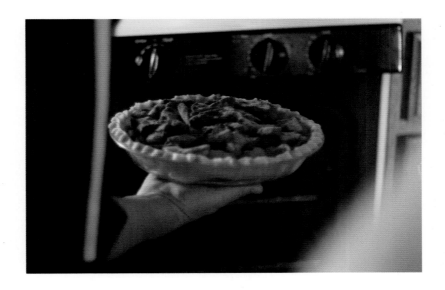

BY CUTTING HER DOUGH long enough to overhang the pie plate, your Amish host has enough dough to crimp the edges of her crust. It looks nice that way, but it also keeps the dough from shrinking down during baking—which means she can fill her pies to the brim with scrumptious filling. Then into the hot oven they go. Before long the downstairs rooms will be filled with the good smell of baking pie.

"They shall celebrate the fame of your abundant goodness,
and shall sing aloud of your righteousness."
—PSALM 145:7

WITH THE PIES well on their way, you'll want to take some time to look around. Near the stairs you'll find some hats, ready for the men and boys to grab on their way out the door. Amish communities prescribe the kind of hats the men can wear. The styles, down to the width of the brim, are outlined in the *Ordnung*. The *Ordnung* may be unwritten, but its details are neither ambiguous nor optional. Everyone knows what the rules are, and everyone who has joined the church is expected to follow them.

> *"If then there is any encouragement in Christ, any consolation from love, any sharing in the Spirit, any compassion and sympathy, make my joy complete: be of the same mind, having the same love, being in full accord and of one mind."*
> —PHILIPPIANS 2:1-2

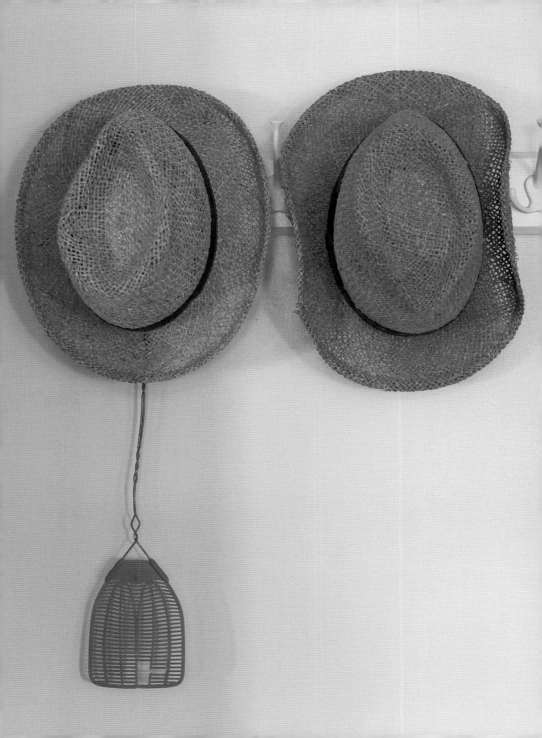

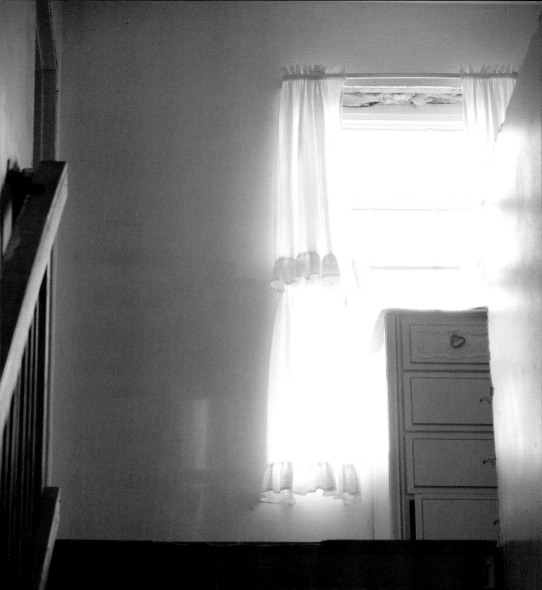

A WOODEN STAIRCASE leads upstairs to the family's bed-rooms. The notion of each child having his or her own bedroom is foreign to Amish life. In fact, many Amish children share their bedroom with two or three or even four siblings. This unchosen togetherness is good training for adulthood, when Amish church members are expected to sacrifice their personal desires for the common good. It is also an early reminder that privacy is a rare commodity in Amish life.

> *"You shall put these words of mine in your heart and soul.*
> *. . . Teach them to your children, talking about them when*
> *you are at home and when you are away, when you lie*
> *down and when you rise."*
> —DEUTERONOMY 11:18-19

AS YOU ENTER the master bedroom, your eyes will be drawn to the hats and head coverings stacked neatly on the dresser. Although the details of the women's prayer covering vary from one Amish community to the next, the purpose of wearing it—to demonstrate submission to God—is the same throughout Amish life. The men wear black hats to Sunday services, a departure from their everyday straw hats and a difference that marks the sacredness of the day.

> *"Store up for yourselves treasures in heaven, where neither moth nor rust consumes and where thieves do not break in and steal. For where your treasure is, there your heart will be also."*
> —MATTHEW 6:20-21

THE JOURNEY WANDA E. BRUNSTETTER LARGE PRINT EDITION

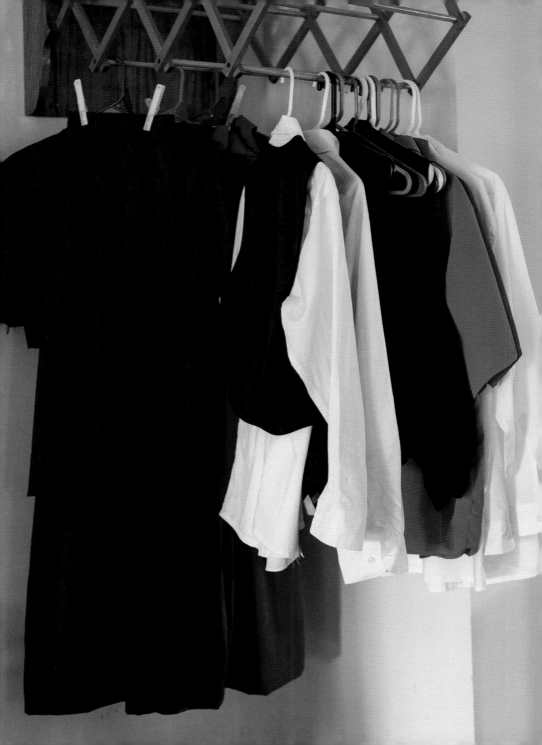

———————

HANGING ALONG THE BEDROOM WALL you'll find some colorful dresses. Everyday dresses come in a variety of colors, including brown, purple, blue, green, and burgundy. Younger women and girls may wear brighter colors. Dresses are usually worn with an apron in white or black. A cape—an extra piece of fabric that covers the top half of the dress—may also be worn. Dress patterns vary according to church district. In all cases, the values of modesty and humility rule the day. Calling attention to oneself by wearing a unique style is a worldly value, not an Amish one.

> *"Strength and dignity are her clothing, and she laughs at the time to come. She opens her mouth with wisdom, and the teaching of kindness is on her tongue."*
> —PROVERBS 31:25-26

HERE'S SOMETHING that might remind you of your grandmother's house: a treadle sewing machine draped with a half-finished dress. Almost all Amish women know how to sew, and many of them make clothing for themselves and their family members. If you have time to stop at the Amish-owned store on your way home, you're likely to find an aisle devoted to fabrics, needles, and threads of all kinds.

> *"But the wisdom from above is first pure, then peaceable,*
> *gentle, willing to yield, full of mercy and good fruits,*
> *without a trace of partiality or hypocrisy."*
> —JAMES 3:17

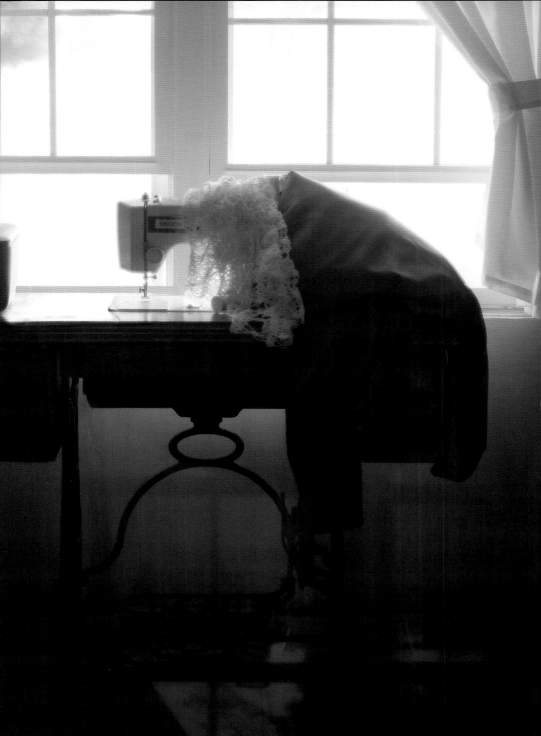

———

AS YOU HEAD OUTSIDE to explore the garden, you'll cross the porch—and perhaps spot huge bunches of onions. Harvested the day before yesterday, they will hang that way—in a shady, well-ventilated place—to dry for the next four or five weeks.

"For the Lord is good; his steadfast love endures forever,
and his faithfulness to all generations."
—PSALM 100:5

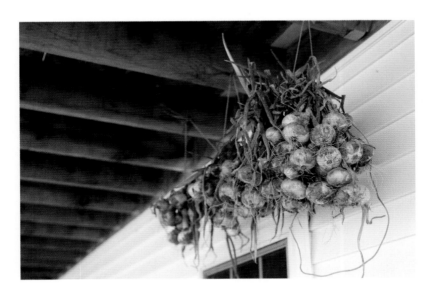

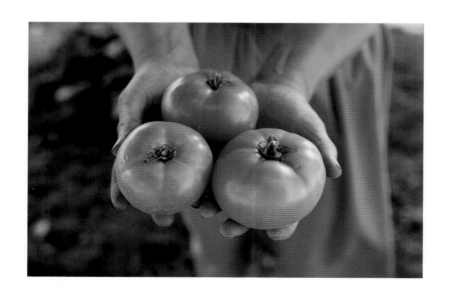

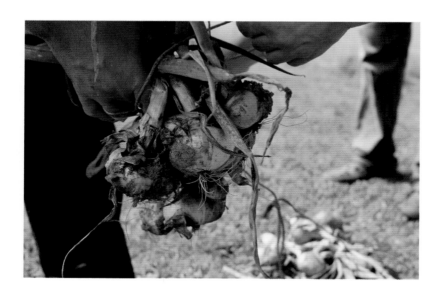

72

AT THE GARDEN you get a closer look at some of the family's produce: the tomatoes freshly picked and the garlic freshly dug. Like many Amish families, your hosts grow enough tomatoes to preserve some for the winter—as juice, sauce, or simply whole. As for the onions, some of them may be used to flavor spaghetti sauce or other dishes. Many Amish families take produce like this to a local market, where it fetches a good price.

"You crown the year with your bounty; your wagon tracks overflow with richness."
—PSALM 65:11

MAKING APPLE BUTTER is best done outside. The ingredients are simple—apples (peeled and quartered), cider, sugar, cinnamon, and cloves—but the process is long and hot. For much of the day the mixture looks like apple soup, but if you cook it long enough, it will thicken up and get darker. Then it's time to simply keep stirring, which is easier with a long stirring paddle fashioned just for this purpose.

> *"He who supplies seed to the sower and bread for food*
> *will supply and multiply your seed for sowing and increase*
> *the harvest of your righteousness."*
> —2 CORINTHIANS 9:10

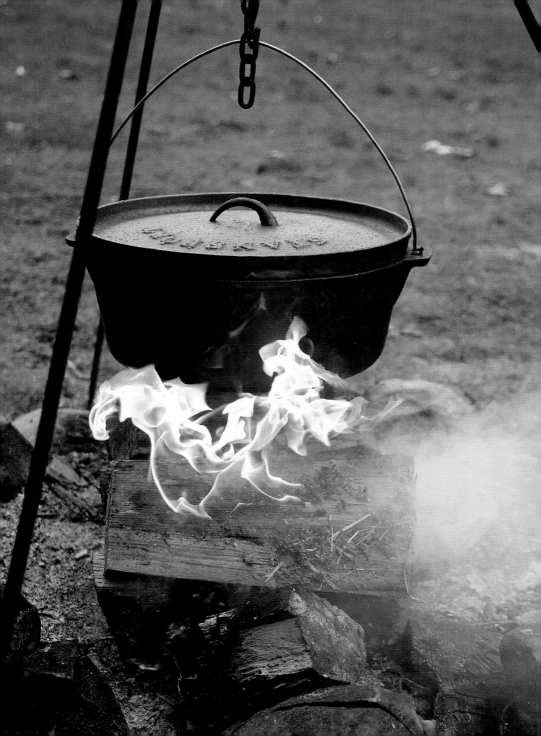

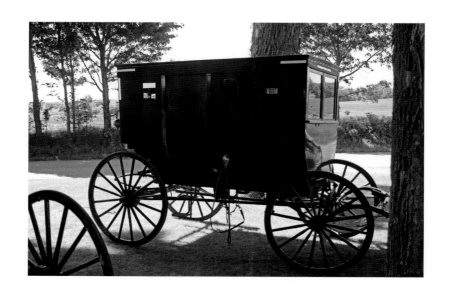

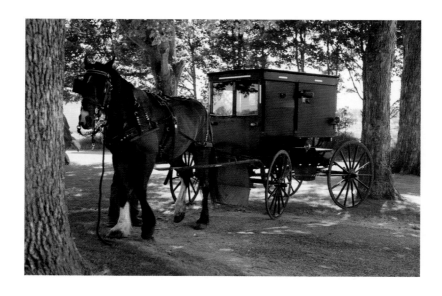

THE FAMILY'S HORSE AND BUGGY has returned from a trip to town. A district's *Ordnung* prescribes various features of the buggy, or carriage, including its color. In some Amish communities you might find a gray-, white-, or even yellow-topped carriage, but in this community the carriage top must be black.

Large Amish communities have at least one carriage maker, but families who live in smaller Amish communities often have to order their buggies from other Amish settlements. The craftsmanship that goes into Amish carriages is exquisite, and a new high-quality carriage can cost as much as $10,000.

> *"By the tender mercy of our God, the dawn from on high will break upon us, to give light to those who sit in darkness and in the shadow of death, to guide our feet into the way of peace."*
> —LUKE 1:78-79

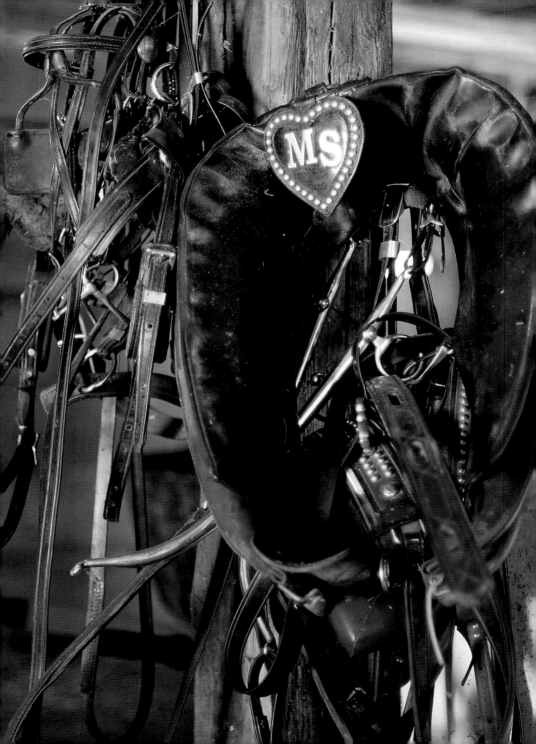

GOOD CARRIAGE HORSES are both valuable possessions and beloved friends. In addition to owning one or more carriage horses, Amish families who farm for a living have draft horses or mules to help in the fields—plowing, planting, harvesting, and pulling wagons. Farm families also need various kinds of bridles, halters, straps, and reins, which are sometimes made locally by an Amish harness maker.

"The earth has yielded its increase; God, our God, has blessed us."
—PSALM 67:6

ENCLOSED CARRIAGES are the most widely used vehicles in Amish communities, but many Amish families own other modes of horse-drawn transportation. When the weather is nice, family members may decide to use this cart to pick up some groceries at a local store. The cart might also be used by a teenager going to work or to a youth gathering. The orange slow-moving vehicle sign helps to alert vehicles approaching from behind.

"Live your life in a manner worthy of the gospel of Christ, so that . . . you are standing firm in one spirit, striving side by side with one mind for the faith of the gospel."
—PHILIPPIANS 1:27

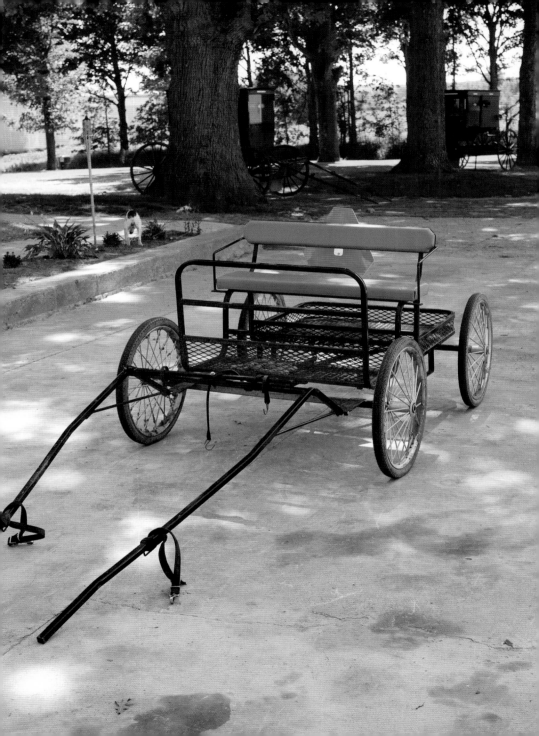

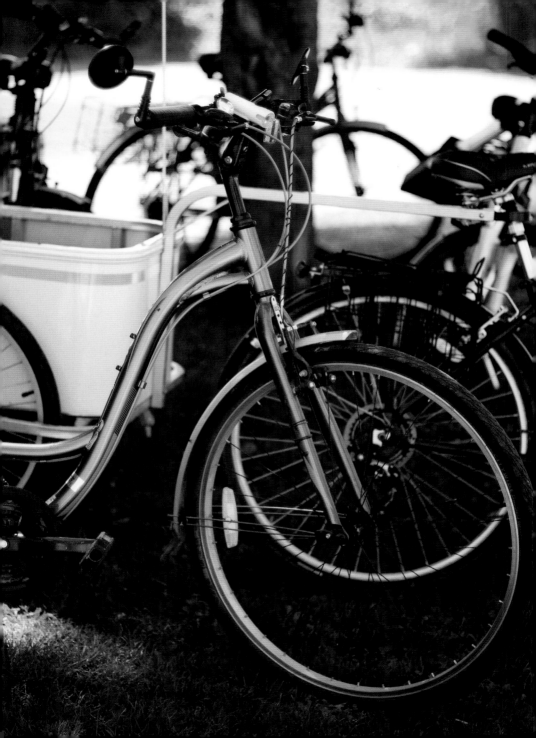

SOME AMISH COMMUNITIES forbid the use of bicycles, but in this community they are widely used. Children ride them to school, and adults use them to visit friends and neighbors. Some bikes are equipped with baskets for hauling groceries, produce, or other items.

"Believe in the light, so that you may become children of light."
—JOHN 12:36

THE FAMILY'S WORKSHOP has been cleaned out and prepared for Sunday worship. The Old Order Amish don't have dedicated church buildings; instead, they meet in church members' homes, barns, or workshops. As their turn to host their district's gathering approaches, a family faces busy weeks of cleaning and preparation. Benches are delivered by way of a bench wagon, a horse-drawn wagon that the church district uses to haul benches between the homes where services are held. The benches are then set up in rows, and hymnals are set out for use during a three-hour worship service.

"For where two or three are gathered in my name, I am there among them."
—MATTHEW 18:20

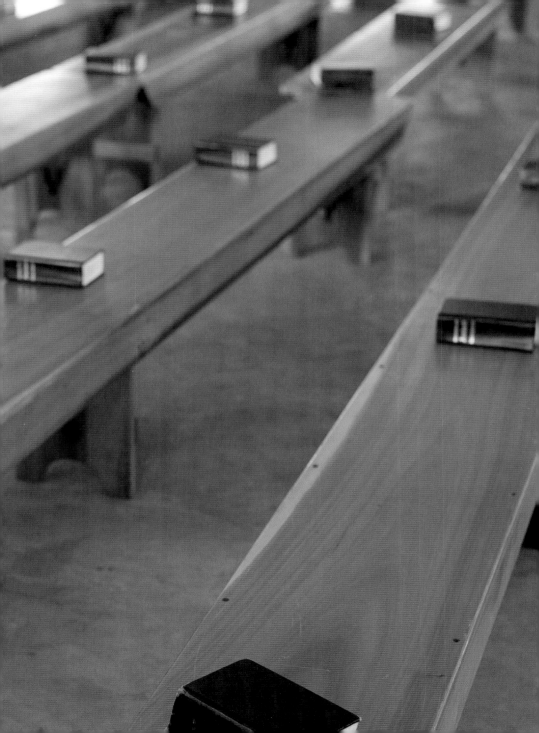

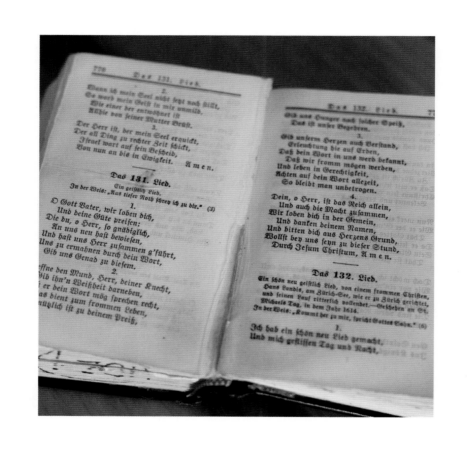

2.
Wann ich mein Seel nicht setzt noch stillt,
So wird mein Geist in mir unmild,
Wie einer der entwöhnet ist
Allhie von seiner Mutter Brust.
3.
Der Herr ist, der mein Seel erquickt,
Der all Ding zu rechter Zeit schickt,
Israel wart auf sein Bescheid,
Von nun an bis in Ewigkeit. Amen.

Das 131. Lied.
Ein geistlich Lied.
In der Weis: „Aus tiefer Noth schrey ich zu dir." (3)

1.
O Gott Vater, wir loben dich,
Und deine Güte preisen:
Die du, o Herr, so gnädiglich,
An uns neu hast bewiesen,
Und hast uns Herr zusammen g'führt,
Uns zu ermahnen durch dein Wort,
Gib uns Genad zu diesem,
2.
Oeffne den Mund, Herr, deiner Knecht,
Gib ihn'n Weißheit darneben,
...er dein Wort mög sprechen recht,
...as dient zum frommen Leben,
...nutzlich ist zu deinem Preiß,

Gib uns Hunger nach solcher Speiß,
Das ist unser Begehren.
3.
Gib unserm Herzen auch Verstand,
Erleuchtung hie auf Erden,
Daß dein Wort in uns werd bekannt,
Daß wir fromm mögen werden,
Und leben in Gerechtigkeit,
Achten auf dein Wort allezeit,
So bleibt man unbetrogen.
4.
Dein, o Herr, ist das Reich allein,
Und auch die Macht zusammen,
Wir loben dich in der Gemein,
Und danken deinem Namen,
Und bitten dich aus Herzens Grund,
Wollst bey uns seyn zu dieser Stund,
Durch Jesum Christum, Amen.

Das 132. Lied.
Ein schön neu geistlich Lied, von einem frommen Christen,
Hans Landis, am Zürich-See, wie er zu Zürich gerichtet,
und seinen Lauf ritterlich vollendet.—Geschehen an St.
Michaels Tag, in dem Jahr 1614.
In der Weis: „Kommt her zu mir, spricht Gottes Sohn." (6)

1.
Ich hab ein schön neu Lied gemacht,
Und mich geflissen Tag und Nacht,

———

THE AMISH HYMNAL, called the *Ausbund*, contains 140 hymns in the German language. Most of the *Ausbund*'s hymns were written in the sixteenth and early seventeenth centuries, many of them by Anabaptist prisoners or martyrs. The early Anabaptists were persecuted, and a variety of groups, including the Amish and Mennonites, remember these early forebears of their faith today.

The *Ausbund* contains no musical notes. Rather, the hymns are sung to traditional tunes that the singers know by heart. Visitors would find the pacing of the songs very slow. Indeed, some churches take twenty minutes or even longer to sing an *Ausbund* hymn with four verses.

> "*Worship the Lord with gladness; come into his presence with singing.*"
> —PSALM 100:2

IN ADDITION to using the *Ausbund* during Sunday worship, Amish families have other books they read for spiritual guidance and renewal. The Bible, especially the New Testament, is read regularly in Amish homes, as are prayers from *Die ernsthafte Christenpflicht* (The Prayer Book for Earnest Christians). Amish families pray silently before family meals. After breakfast or dinner, families often have a devotional time that includes Bible reading along with a read or spoken prayer.

"Pray in the Spirit at all times in every prayer and supplication. To that end keep alert and always persevere in supplication for all the saints."
—EPHESIANS 6:18

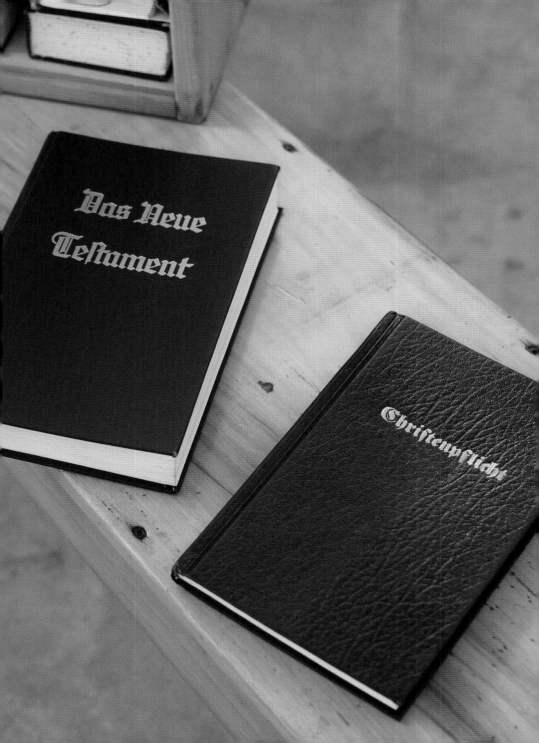

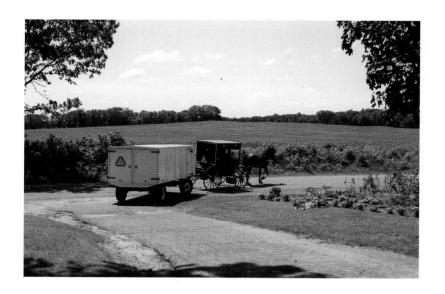

NEXT WEEK, after Sunday worship has taken place here, the benches will be loaded into the bench wagon and the wagon will be transported to the next host family's home. Amish congregations meet every other week, a practice rooted in earlier times when traveling was more difficult than it is today. These "off weeks" give Amish church members the chance to visit other Amish churches, although many Amish families simply remain at home and enjoy a more relaxing Sunday.

> *"A sabbath rest still remains for the people of God; for those who enter God's rest also cease from their labors as God did from his."*
> —HEBREWS 4:9-10

W e hope you've enjoyed your visit to an Amish home. It's
not exactly a trip back in time, but the rhythms of Amish
home life do recall for many people an earlier era. It's a life with
far fewer conveniences than most people take for granted. But it's
a life filled with simple beauty, lively community, and deep faith—
if only you take time to look.